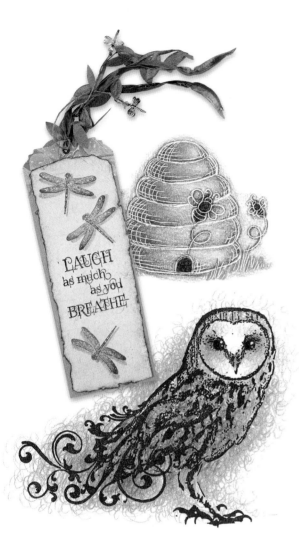

Introdu

This book teaches even complete beginners fun pencil techniques that allow them to create amazing cards, paper art projects, Zentangle® art, and more! It includes fresh techniques, such as zero drawing and impressed line drawing, along with traditional drawing strokes and shading like hatching and crosshatching, strike stroke, and scumbling. You'll also learn a bit about drawing and color theory to really get a good grasp of what you can do. And it's all taught for both graphite and colored pencils, so you can express yourself in whatever shades you like.

Don't say that you can't draw—of course you can. It's a learned skill, and is more about leaning how to see than learning how to put pencil to paper. It does take a passion for art to practice and master it, but if you've picked up this book, you probably have that passion! You will be successful from the very start by using preexisting artwork in the form of a stamp or stencil to get you started. Using stamps or stencils gives you confidence by having your drawings turn out beautifully right from the start, and it also simply gets your pencil onto the paper—no more hesitation. Pick up that pencil and start learning! Beginning to draw is powerful, inspiring, and rewarding. You'll soon be foregoing stamps and stencils to express your imagination freely through your pencil. So enjoy the skills, techniques, and project ideas presented in this book, and let's get drawing!

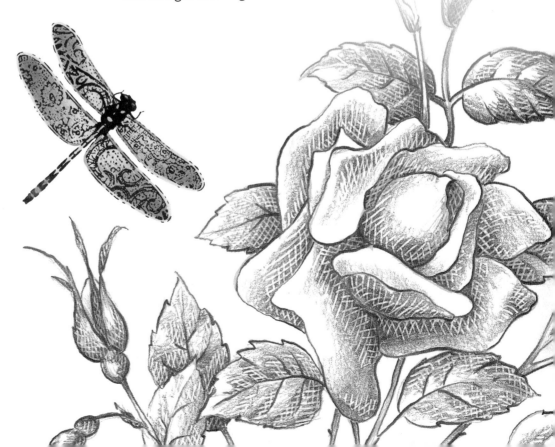

Contents

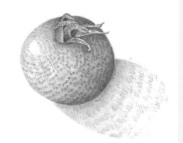

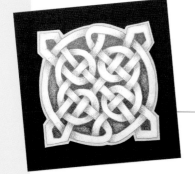

GRAPHITE PENCILS

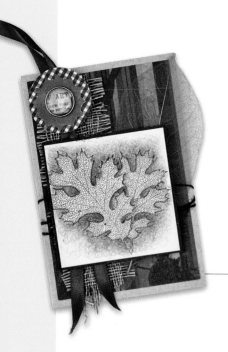

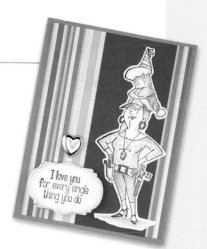

COLORED PENCILS

All About Graphite Pencils

The simple pencil is what great people use to create great art. Sculptures, architecture, and symphonies start with a humble pencil sketch or note. You will get to start your masterpieces with quality drawing pencils of different point strengths, and mechanical pencils, too.

Pencils have two main components: a graphite core, known as the lead, and a plastic or wooden body that encases the lead. Some pencils have an eraser at one end. Modern pencils got their start in Roman times when lead was used to make marks on papyrus. Modern pencils do not actually contain any lead; they are made with nontoxic graphite. A large deposit of graphite was discovered in England in 1564 and quickly replaced lead, as it leaves a darker mark. However, graphite is very brittle and requires a holder to prevent it from breaking. Graphite pieces were first wrapped with string and then later inserted into hollowed-out wooden sticks: thus the wood-cased pencil was born.

In the early 1900s, pencil manufacturers needed new sources for wood. Incense cedar from California's Sierra Nevada mountains was found to be a superior wood for pencil manufacturing and soon became the top choice for quality pencil makers around the world. The incense cedar woods are harvested on a sustained-yield basis. Sustained-yield means that the annual growth of the forest is greater than the amount of wood harvested from the forest.

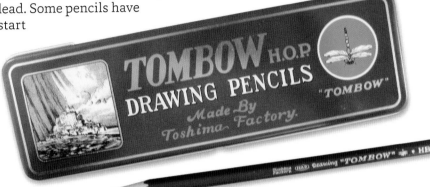

In 2013, Tombow celebrated its 100th birthday in making superior pencils and premium drawing and office supplies. Shown here is the Vintage Collectors Edition pencil set.

Hardness

Depending on how hard the lead is, pencils make different marks. A hard pencil lead leaves light, fine marks that are great for drawing precise details. A soft pencil lead leaves dark, heavy marks that are typically used for filling in large areas, or for shadows. It mainly comes down to personal preference which leads you choose to use; you have to play around to figure out what works for you. Not all pencil leads are created equal, though: they vary in strength, smoothness, smudge resistance, and hardness.

My preferred pencils, and the pencils used in this book, are Tombow drawing pencils, which offer superior, extra-refined, high-density graphite. They are super smooth when drawing and shading, making it easy to create perfect graduated shades. They have a high point strength and are break resistant. Smear-proof lines help produce crisp, clean drawings with the added value of slow wear for smooth, dense writing. They are available in point strengths from very hard, 6H, to very soft, 6B. You can use your choice of pencil while practicing the skills in this book, but keep the pencil quality in mind as you shop.

According to the European scale system, pencils are graded "H" (hardness) and "B" (blackness), with an accompanying number to describe how hard or how black the pencil is. The more H's you have, the harder the lead and the lighter the lines. The more B's you have, the softer the lead and the darker the lines. The designation HB occupies the very middle of the scale; this is the lead in most mechanical pencils because of its suitability for writing. There's also F (fine), which is between HB and B, and which makes dark, fine marks.

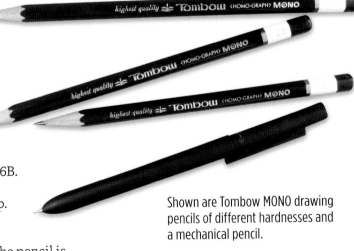

Shown are Tombow MONO drawing pencils of different hardnesses and a mechanical pencil.

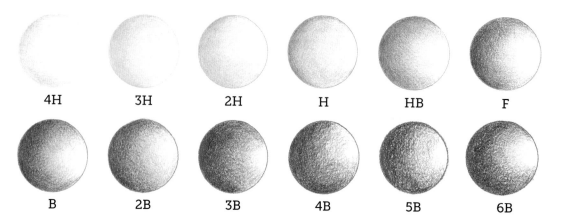

4H 3H 2H H HB F

B 2B 3B 4B 5B 6B

Here you can see shaded circles going from very hard leads to very soft leads. In the middle is the most common mechanical pencil lead, HB, which is very suitable for writing.

Holding a Pencil

The first step to successful pencil drawing is controlling the pencil's movement so every mark you make works toward creating the effect you want. The best grip is the one you already use. Trying to change your grip artificially is probably the worst thing you can do. However, many people ask me the proper way to hold a pencil, so here are a few recommended grips. Try to learn to use these as naturally as possible.

The **basic tripod grip** is most likely what you use for writing. You control your grip with your fingers, and it is an ideal way to hold your pencil for drawing. Your hand rests on the table for support and the upright position of the pencil allows for accurate shading with the tip, rather than the side.

The **extended tripod grip** uses the same hold as the basic tripod grip, but with the fingers further up the pencil. This is a comfortable way to hold a pencil for drawing and allows for more freedom and a light touch when shading.

The **overhand grip** is the grip most often recommended for sketching, as it makes it easy to use the side of the pencil. I also use this grip when edging a panel with graphite or colored pencil. It uses the side of the lead to give a nice dark edge with a graduated blend toward the center.

Tips for graphite pencils:

- Always keep a relaxed grip on the pencil—a tight grip is tiring and restricting.
- Keep your pencils sharp.
- Use small, rapid circular or back-and-forth strokes for general shading.
- Follow the contours of the image as you shade.
- Move the paper around or even turn it upside down as you shade to make it easier to follow the contours.
- Rest your hand on a paper shield to prevent smudging your drawing.
- Use a hard pencil over a soft pencil to even out the tone and fill in the tooth of the paper.
- Use an eraser to lift off highlights.
- Use a tortillon (a blending stump) to blend out tones.
- Use a full range of pencil grades: not just the dark and lights, but also the in-between grades.

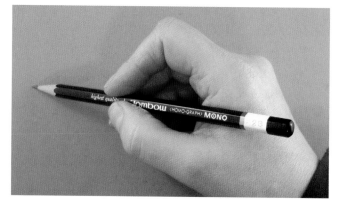

Basic tripod grip

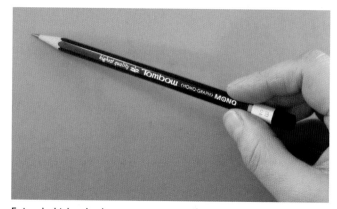

Extended tripod grip

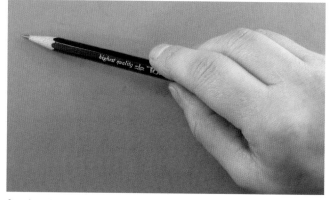

Overhand grip

Supplies

Erasers

White vinyl erasers are useful for erasing large areas. Small erasers in a pen form, such as Tombow's zero erasers, are excellent for getting into small areas and are crucial for the zero drawing technique. Sometimes a sand eraser, with its slightly abrasive quality, is needed to erase dark pencil marks made with soft leads.

Tortillon

A tortillon, also called a blending stump, is a rolled piece of paper with a pointed tip. Tortillons are inexpensive, come in a variety of sizes, and are excellent for helping beginners get a soft, graduated blend. See page 9 for more detail about this tool.

Paper Shield

A shield is simply a piece of clean paper placed on top of your in-progress piece that you set your hand on to prevent smudging your piece as you draw and move your hand.

Low-Tack Masking Tape

Make your own low-tack tape by placing a piece of regular masking tape on your clothing before using it. The tape collects some fuzz, which lessens the stickiness to achieve a low-tack quality.

Dust Brush

A dust brush is a large, clean, mop-style brush for removing graphite dust and eraser bits from your drawing.

Graphite Applicator Pouch

This is a homemade tool that you use to pick up graphite dust and apply it to paper to create gray backgrounds. To make one, first choose an 8" (20cm) square piece of soft fabric. Place a small handful of fiberfill into the center of the cloth and gather up the corners, making a firm, wrinkle-free ball. Gather the excess fabric into a handle using 3 to 4 rubber bands, and then trim away any excess. Your homemade tool will work great.

Pencil Sharpeners

Handheld sharpeners, electric sharpeners, or sanding blocks (such as sandpaper on a paddle) all work well with graphite pencils. Sanding blocks are useful for making chisel points, which result in a point for fine details and a flat area for precision shading. You can also use the sanding block for the zero drawing technique.

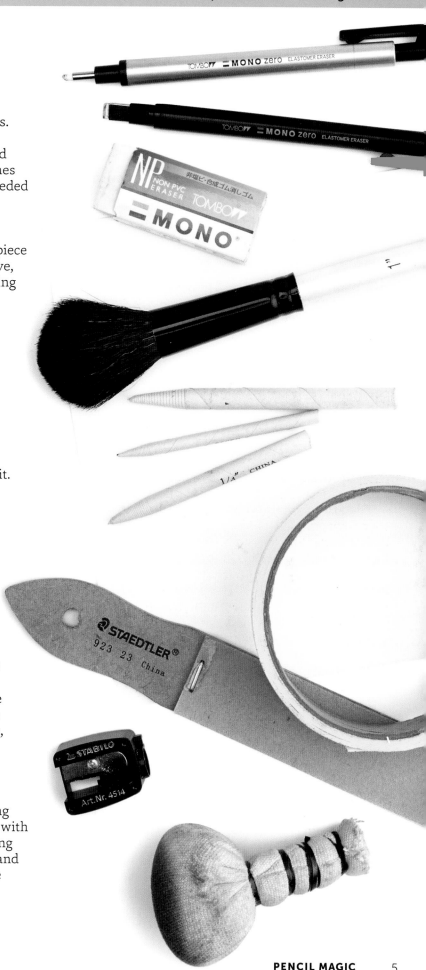

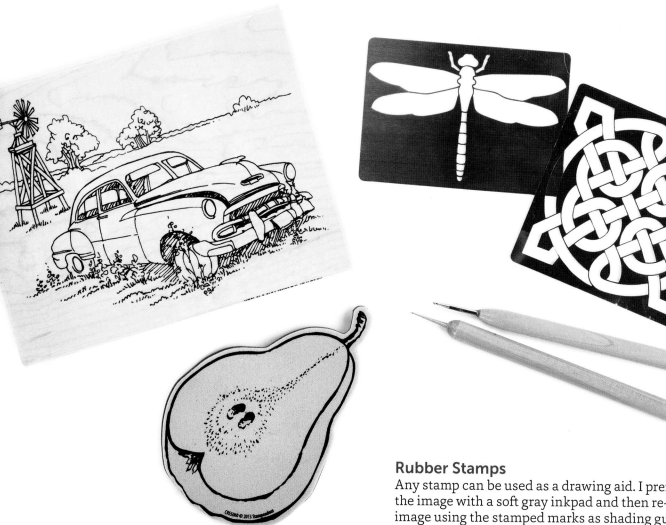

Workable Fixative

This fixative is a spray for protecting your work when it is finished. I prefer the workable type, as it allows you to work on your drawing if needed after the spray has been applied and dried.

Paper

Use good quality drawing paper, the best you can afford. A good buy is a pad of drawing paper for pencil. Look for paper at your local art store. There is a lot of fine drawing paper out there. My favorites include:

- **Stonehenge:** beautiful 100% cotton paper with a vellum finish. I reserve this for my large, fine drawings.
- **Canson mixed media paper:** two-sided paper with a medium and a fine texture surface and excellent erasability.
- **Canson 1557 drawing paper:** nice French paper, two-sided, with a medium and a fine texture surface.
- **Canson Fine Art Paper Sampler:** a great little coil-bound book with samples of Canson papers; it provides a great opportunity to try many different papers. It also contains educational materials.

Rubber Stamps

Any stamp can be used as a drawing aid. I prefer to stamp the image with a soft gray inkpad and then re-draw the image using the stamped marks as shading guides. Take a good look at the stamps I choose for each technique to help you select the right image. Stamps are a great way for beginners to get into drawing and produce beautiful pieces right from the start. Digital images are also a favorite—they can be enlarged or reduced to different sizes and printed right onto drawing paper that has been cut to size before loading into your printer.

Inkpads

I use mainly black and gray inkpads for graphite pencil drawings.

Stencils

Small metallic stencils are used for the zero drawing technique. Background stencils, large open-spaced stencils, and motif stencils all work great. Do not use plastic stencils for zero drawing, as the vigorous erasing will damage them.

Embossing Stylus

An embossing stylus is used for the impressed line drawing technique. A double-ended stylus with tiny 1mm and 2mm ball ends works best. Collect a selection of styluses with different sized ball ends for variety.

Elements of Art: Basics

Elements of art are the building blocks of a drawing. You learn to manipulate these elements to produce a great work of art. Not only do you need to know the basic elements to create art, they also help when you are describing your art piece, or, in this case, describing how to create it.

Line
A line can define a shape, create a pattern or texture, imply movement, or create mass. Lines can be thick or thin, long or short. Lines can also create shading using hatching and crosshatching. Lines in the garlic drawing outline the shapes and also add pattern to the papery peelings off the bulb.

Texture
Texture is the surface quality, created using lines, values, and shapes. Real texture is felt, while implied visual texture is seen through line, value, and shapes in a two-dimensional drawing. Texture is used in the garlic image to show the difference between the thin papery peelings and the smooth, solid bulb.

Space
Space refers to distances or areas around, between, or within components of a piece. It is the background, foreground, and middle ground of a drawing. There is negative space (the dark areas) and positive space (the white areas). Space doesn't actually exist within a piece, but the illusion of it does.

Shape
The shape, or form, of an object is defined by line, texture, and value. Shape can be geometric, such as square, round, or triangular, or it can be organic, with broken or irregular edges. Shape in drawing is limited to two dimensions: length and width. The garlic has a basic triangular form, with an organic irregular edge.

Value
Value, or tone, is the light and dark, the shades and highlights. Value becomes critical when rendering graphite drawings, which have no colors other than black, white, and grays. The values in the garlic drawing help to define the shapes of the cloves in the bulb.

Color
Color, the final basic element of art, is discussed in the colored pencil section on page 28.

Masking a Stamped Image

This is a valuable skill you'll want to use when working with stamps while executing the techniques in this book. It is an easy way to differentiate foreground and background images within your composition.

1 Make a mask by stamping the foreground image onto a piece of 20 lb. bond paper. Cut out the image and add some removable adhesive to the back.

2 Stamp the foreground image onto the drawing paper. I used a gray inkpad for the sample.

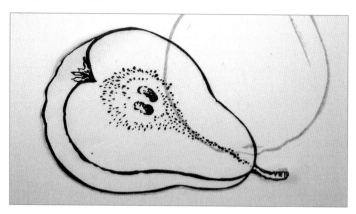

3 Cover the foreground image with the mask and then stamp the background image on top of the masked foreground image.

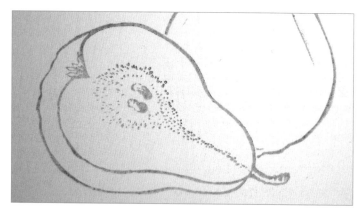

4 Remove the mask to reveal the completed stamping. Store the mask with the stamp to use again and again.

All About Shading

The different types of shades in a drawing are named to help describe the shadows and highlights in the piece. The more dramatic the dark black shadows and the bright white highlights, and the more the shades of gray in between, the more successful the drawing will be. This contrast is something I feel is important for beginners to pay attention to.

A **highlight** is created where light is shining on an object. For very hard and shiny objects, the difference between the highlights and the shadows is harsh and bold, whereas diffusely lighted items have a blended difference between the highlights and shadows.

A **form shadow** is where the light is not hitting an object, creating shades from black to the lightest gray on the object itself.

A **cast shadow** is the shade that is cast by an object. The cast shadow can be very hard and black when direct, strong light is on the object, or it can be soft with many shades of gray when diffused light is on the object.

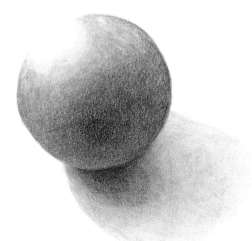

Highlight, form shadow, and cast shadow on a sphere.

Transferring a Pattern

This skill allows you to transfer your personal photographs to drawing paper, which opens up a whole new world of possibilities for your designs and creations.

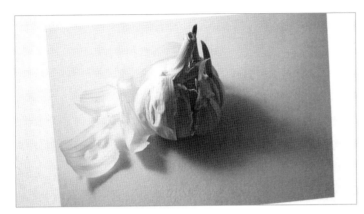

1 Print the photograph out in black and white on regular 20 lb. copy paper.

2 Turn the photo over and cover the back with an even coating of graphite using a soft 4B or 5B pencil.

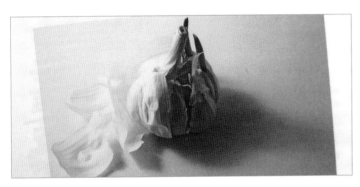

3 Tape the photo in place on drawing paper with low-tack masking tape. Trace over the entire image with a hard 3H pencil or an embossing stylus. Take a peek after a few lines to check your pressure—you want to press hard enough to get a faint line, but not so hard that you dent the paper.

4 After tracing all the lines, check again to make sure you didn't miss anything before completely removing the photo.

Blending with a Tortillon

The sphere shown on the left has been shaded with a graphite pencil only; the sphere on the right shows how a softer shadow with more gray tones can be created when the graphite pencil is blended with a tortillon, or blending stump. Different sizes of tortillons can be used to get into small spaces or to blend large areas. When working with a tortillon, push hard in the dark areas to move lots of graphite, and lighten up pressure when working in the lighter tones. Use the side of the tortillon—if you use the point straight up and down, it will push in the point. Restore the point by pushing it back out from the inside with a piece of wire (an unbent paperclip will work). You can also sharpen the point or remove graphite by sanding the tortillon on a clean sanding block.

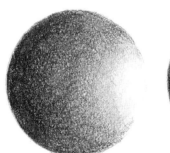

On the left, the sphere has been shaded with graphite pencil; on the right, the graphite pencil shading has been blended with a tortillon.

TECHNIQUE 1:
Value Drawing

This drawing technique is done with tones only: the lines are created by the differences between the light and dark areas. The only outlines included are from the original stamped image. The aim of a realistic drawing like this one is to show the contrast between light highlights, dark shadows, and all the shades in between, to create a three-dimensional drawing.

Materials

- Graphite pencils (soft: B, 2B, 3B, 4B)
- Stamp
- Gray inkpad
- Graphite applicator pouch
- Sanding block
- Eraser
- Tortillon
- Drawing paper

1 Stamp an image onto your drawing paper using a gray inkpad. To create the gray background, scribble the tip of a soft 3B or 4B pencil onto a sanding block. Pick up the fine graphite dust with the applicator pouch by pouncing it on the sanding block surface in an up-and-down motion. (A swiping motion with the pouch across the sandpaper will render your pouch useless as it sands through the fabric.) Transfer the graphite dust to the paper and apply it using a firm circular motion all over the stamped image. Repeat two or three times until you have a soft gray surface.

2 Using the markings from the stamp as your guide, erase all the highlights with an eraser. Small zero erasers are perfect for this task. Use a round zero eraser for small, tight spaces and a rectangular zero eraser for the larger areas and for thin lines such as the highlights on the stems.

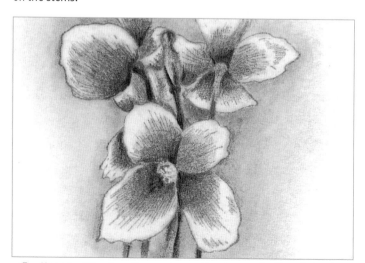

3 Again using the markings from the stamp, add the dark shadow areas with a soft B or 2B pencil. Blend these areas out with light pressure on the pencil point. Here the darkest areas are the center of the flowers and where the stems go in behind the flowers.

4 Use a tortillon to soften and smooth out your shading. Go back into the drawing with a hard H pencil to refine the shadow details. Pay attention to the highlighted areas against the darker areas, and sharpen the edges of the petals. Bring back highlights or tone down areas using zero erasers. Use the tortillon to darken the background against the edges of the petals to minimize the stamped lines.

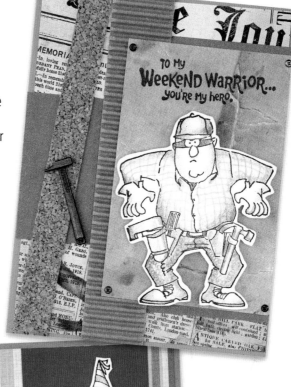

The two card designs with people on them had their focal points shaded with pencils. Note the different textures in the clothing: lines or dots depict patterns in the clothing, and, in the weekend warrior image, a scribbling stroke creates the texture in the jeans.

The panel with the stamped saying also includes shading on the edge. The black and white shaded images contrast nicely against the colorful backgrounds and are a nice change from color images, channeling the charm of black and white photographs.

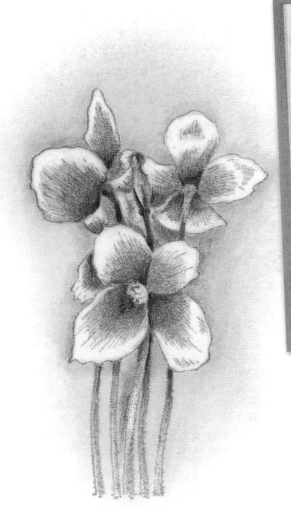

The stamped dragonfly bookmark shows how even a small amount of pencil shading can dramatically change a stamped image. The dragonflies were stamped with a colored inkpad, and then the shadows were drawn in using an HB or F drawing pencil.

Technique 2:
Drawing with Lines

In this drawing exercise, you will be outlining and shading the image with lines in the style of Leonardo da Vinci. The outline is made with a contoured line, which is drawn with different pressures to give it a varied width and darkness. The shading uses hatching, or straight lines all moving in one direction, to show the values of the drawing. The strokes are applied darkly and close together where you want darker shading, and lightly and separated for softer shading. Look at da Vinci drawings for more inspiration when drawing with this technique.

Materials

- Graphite pencils (soft: 2B, 3B; and hard: 3H, 4H)
- Stamp
- Gray inkpad
- Drawing paper

1 Stamp your image onto drawing paper using a light gray inkpad. Here I overlapped the image using the masking technique described on page 8.

2 Using a soft pencil such as a 2B or 3B, draw the contour lines (lines that follow the edges of the drawing subject), applying varying pressure so the lines have thick and thin and dark and light areas. Look carefully at this example to see where I have chosen to apply more pressure for the darker, thicker lines.

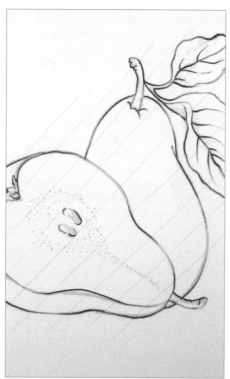

3 Using a hard 3H or 4H pencil and with very thin and light marks, draw parallel lines across the entire image to denote the direction of the hatching strokes for the shading. I usually do not erase these lines on the final drawing.

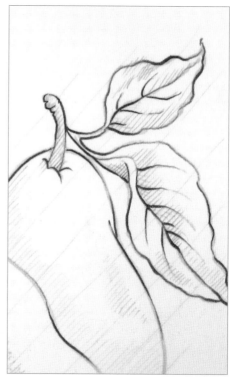

4 Start by adding lightly drawn hatching lines for the shadows, using the shadows on the stamped image as your guide.

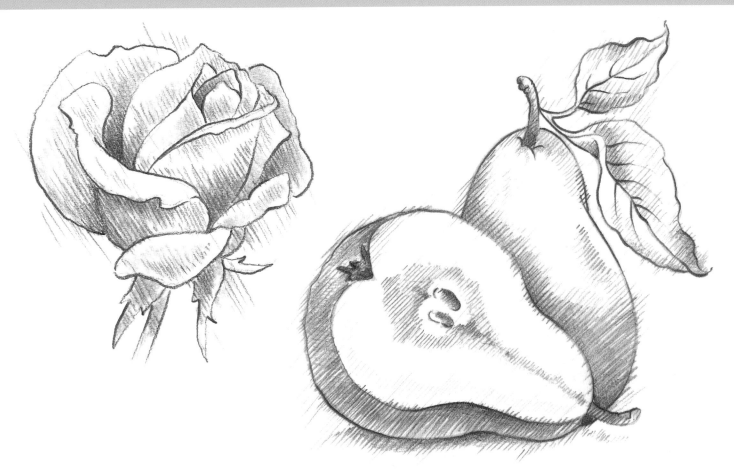

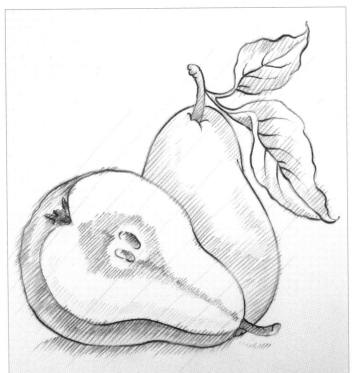

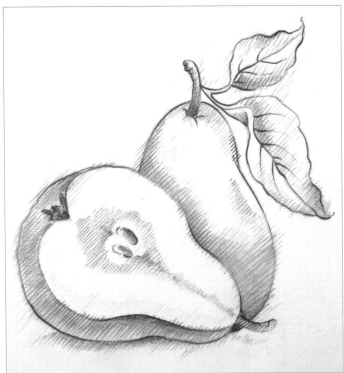

5 Continue to refine the shading by adding darker and lighter hatching for the shadows and highlights. Keep all the strokes parallel and straight using your lightly drawn guide marks from Step 3.

6 You can reinforce the darkest areas with basic shading strokes on top of the hatching. Notice how the hatching goes past the image outline for an interesting da Vinci-like effect.

Technique 3:
Impressed Crosshatching

This drawing technique makes your drawing look like a vintage etching. I find botanical digital images the best for creating these drawings, but you can also use a photograph that has been transferred to the drawing paper. Use large images for best results.

Materials

- Graphite pencils (soft: B, 2B, 3B, 4B)
- Embossing stylus
- Small piece of paraffin wax or old candle stub (not colored wax)
- Drawing paper

1 Print out or transfer your image onto drawing paper. The best images have shadows to use as a guide for shading. I am using a digital image enlarged to fill an 8½" x 11" (or A4) piece of drawing paper. Manipulate the image to print it out in a very light gray.

2 Using a soft pencil such as a 2B or 3B, draw the contour lines (lines that follow the edges of the drawing subject), applying varying pressure so the lines have thick and thin and dark and light areas. Next, use an embossing stylus to heavily impress crosshatching in the darker, shadowed areas of the image (see page 34 for more about crosshatching). I work on a semi-padded surface such as a piece of craft foam or cardboard to maximize these impressed lines. To minimize drag, rub the stylus in paraffin wax to lubricate it. Work with a strong light directly overhead to see the subtle white-on-white impressed lines you are creating.

3 Shade the image using basic shading with soft B, 2B, and 4B pencils, using the shaded areas on the printed image as your guide. As you shade, the impressed lines will appear as white lines. The resulting finished drawing looks like a vintage etching.

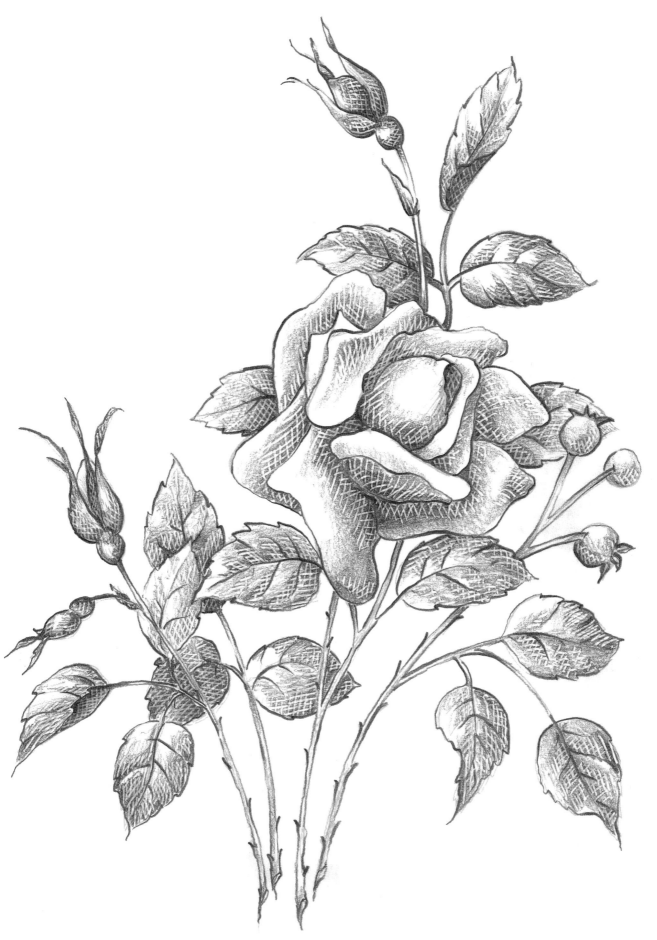

Technique 4:
Shading Zentangle® Art

Using shading on Zentangle art is a great way to learn about basic shading for all your different graphite and colored pencil work! Rick Roberts and Maria Thomas developed the Zentangle method, a form of meditative drawing in which one becomes completely engrossed in making beautiful, simple patterns called "tangles," deliberately focusing on "one stroke at a time"®. The tangles are made with simple strokes and clear instructions. The creative options and pattern combinations are endless, and anyone can do it! Classic Zentangle art is abstract, black and white, and done on a 3½" (9cm) square tile. Follow the tips here to learn about shading Zentangle art, and check out *www.zentangle.com* for more information.

I love making my tangles come alive with shades of lights and darks. The most important thing to remember when shading is contrast: you want everything from deep darks right up to the clearest whites. When working with small motifs, it's important to keep your highlight areas white, but still have dark shadows to create the shape. And don't make the mistake of shading the whole motif; you need the white to create the illusion of the shape.

Materials

- Graphite pencils (soft: B, 2B; and hard: H, 4H)
- Permanent pen with fine tip
- Paper or Zentangle paper tile

Basic Shading

1 With a fine-tipped permanent pen, draw a tangle. For this example, Static, an official Zentangle tangle, is used.

2 Use a 2B pencil to draw a line along alternate points of the tangle. You are creating valleys along the pencil line and hills where there is no added line.

3 Shade in the valleys using B and 2B pencils along one side in graduated shading toward the top of the hills. Make the darkest shading at the pencil line, deep in the valley.

4 Shade the other side of the valley in graduated shading toward the top of the hills. Then refine your shading with a tortillon to soften the shading to white at the top of the hills. If needed, darken the valleys with a darker line and use an eraser to bring the hilltops back to white.

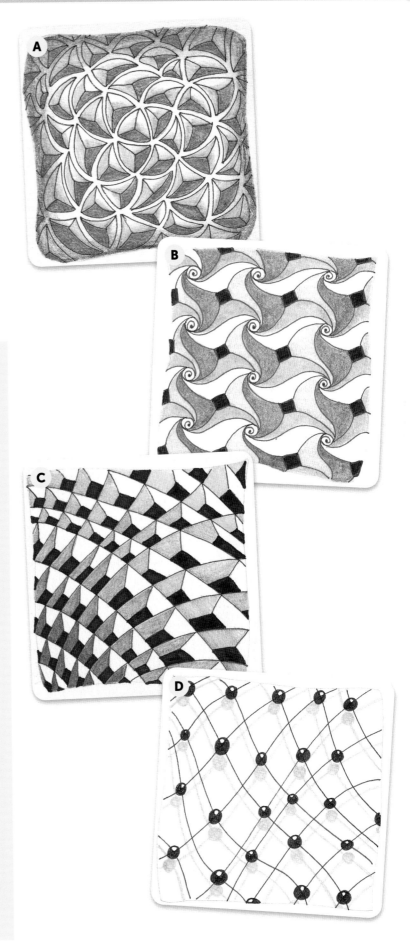

Other Ideas for Shading

Shade around whole tangles at the string.

A. The "string" is the freeform pencil pathway drawn to define areas to tangle within a tile. After adding the tangle, shade all around the tangle at the string with a soft 2B pencil. Refine the shading with a hard 4H pencil to sharpen the outline and make the shading more gradual. Blend with a tortillon to soften your shading. (Tripoli, official Zentangle tangle.)

Shade individual motifs within a tangle for a 3-D effect.

B. Many types of grid tangles change dramatically with the addition of shading. In each grid, shade in the motif on the left side using a 2B pencil and on the bottom side using a hard H pencil. Then rub the tortillon in the darker sections and apply the graphite on the right side of each grid. Leave the final section white. (Cadent, official Zentangle tangle.)

Create a gradation with shading.

C. This tangle is shaded to create a graduated value from dark to light within the entire tangle by using different pencils. In the first three rows of the grid, shade in the motif on the left side using a 2B pencil. In the next two rows of the grid, shade in the motif on the left side using a B pencil. Continue in the next two rows with an F pencil and then in the remaining rows with a 4H pencil. (Cubine, official Zentangle tangle.)

Shade areas near a tangle to create a cast shadow effect.

D. This technique uses a hard pencil to create the shadow, making the tangle appear suspended above the surface. With a hard 4H pencil, mirror the grid lines a little ways from the inked lines. The pencil lines can be slightly thicker than the inked lines. Shade circles at the crossed lines under each black circle. Do not add highlights to the shaded circles, because shadows do not have highlights. (Fish Net, tangle by Mariët Lustenhouwer.)

Technique 5:
Script Stroke

This technique is pure fun and is a good stroke for when you just want something different. For the tomato piece, I used a photograph transferred onto my drawing paper. Light gray stamped and digital images work equally well.

Materials

- Graphite pencils (soft: B, 2B; and hard: F, 4H)
- Tortillon
- Drawing paper

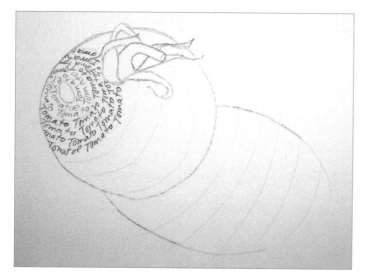

1 Transfer or stamp your image onto drawing paper. With a hard 4H pencil, lightly add contoured lines as guides for your script. These lines will disappear as you shade your drawing.

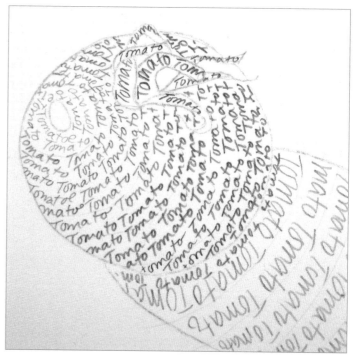

2 Using your own handwriting, add script following the contour lines. For this drawing, I simply repeated the word tomato; you could also scribble nonsense script or write in a poem or whatever you wanted. Write lightly by the highlight and gradually add more pressure for the darker shadows. I made the script larger in the cast shadow to illustrate a difference from the main shape.

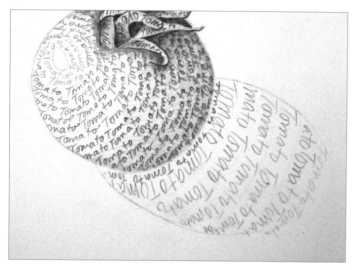

3 Using an F or B pencil, shade in the shadows using basic back-and-forth shading strokes. This helps to define details such as the greenery and stem at the top.

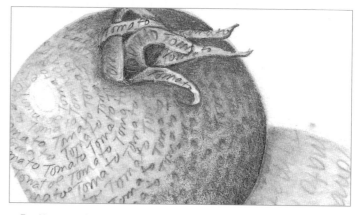

4 Use a tortillon to soften and shade the entire drawing. Adjust the pressure on the tortillon from hard on the darker shadows to light on the lighter values. Refine the drawing by darkening the shadows with a 2B pencil and lightening the highlights with an eraser.

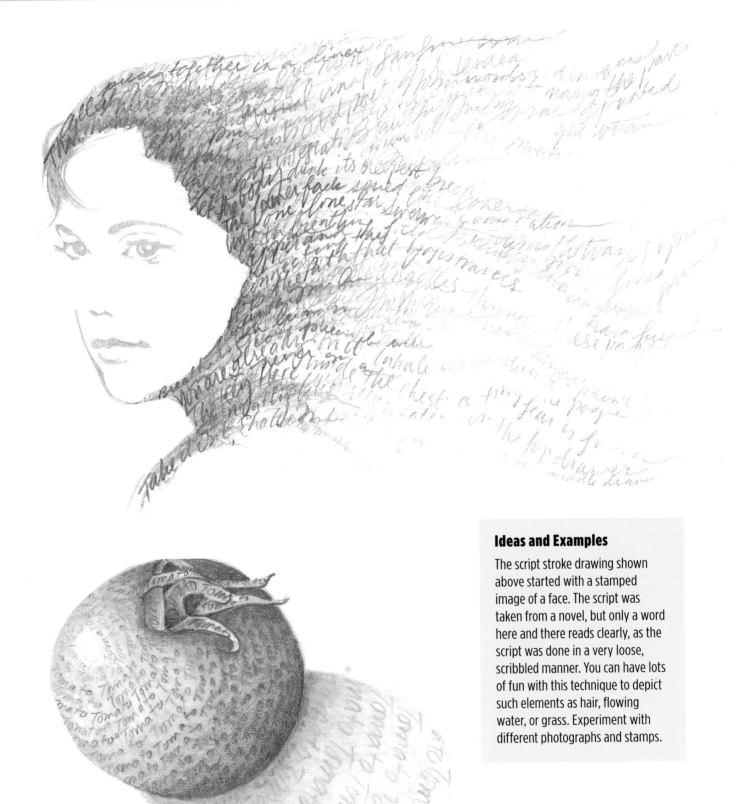

Ideas and Examples

The script stroke drawing shown above started with a stamped image of a face. The script was taken from a novel, but only a word here and there reads clearly, as the script was done in a very loose, scribbled manner. You can have lots of fun with this technique to depict such elements as hair, flowing water, or grass. Experiment with different photographs and stamps.

Technique 6:
Zero Drawing

This drawing technique is the art of removing and requires thin metal stencils, graphite pencils, and erasers to remove the graphite. This technique is generally used with charcoal drawings, but I like the look of graphite for small pieces like the ones shown here. The instructions work with any metal stencil image. Try this technique to make appealing little drawings suitable for framing or presenting on a card.

Materials

- Drawing pencils (soft: 4B through B; and F)
- Sanding block
- Graphite applicator pouch
- Low-tack masking tape
- Metal stencil
- White plastic erasers and small detail zero erasers
- Tortillon
- Dust brush
- Paper shield
- Paper

1 First, prepare the graphite surface. Scribble onto the sanding block using a soft 3B or 4B pencil. Pick up the fine graphite dust with the applicator pouch by pouncing it on the sanding block surface in an up-and-down motion. (A swiping motion with the pouch across the sandpaper will render your pouch useless as it sands through the fabric.) Transfer the graphite dust to the paper and apply it using a firm circular motion. Repeat two or three times until you have a soft gray surface.

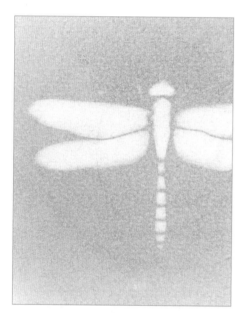

3 Remove the stencil and brush away the eraser bits with the dust brush. Use the small zero eraser to add in any small details that you missed from the stencil. Whiten any large areas with the eraser if needed. You may notice that the tape has removed some of the graphite and left a mark. Remove the mark by rubbing the graphite applicator pouch over the area (but away from the erased image).

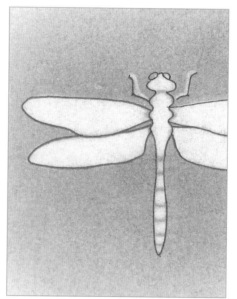

4 Using an HB or F pencil, outline the design so that it doesn't look like a stenciled motif. For example, the bridges on the stencil that created the detail in the lower part of the dragonfly body are ignored and drawn on as one piece. Every stencil is different, so look closely and make decisions that make sense. Use the paper shield to prevent smudging with your hand while drawing.

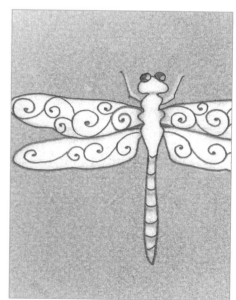

5 Continue using the HB or F pencil to add details to the erased areas. Here a swirl design is added to the wings. You can add simple whimsical designs or realistic details. These lines should be as dark as the outline.

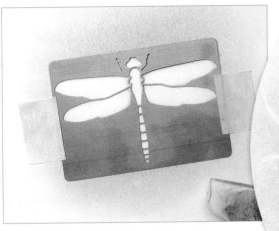

2 Using low-tack masking tape, secure the stencil over the graphite surface. Using the white eraser, firmly erase the open spaces on the stencil. Go in different directions and press firmly into the small detailed areas. You will need to hold the stencil down firmly with your hand as well to prevent it from shifting as you erase.

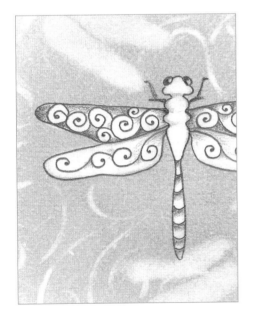

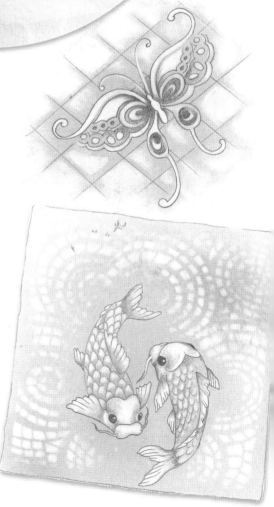

6 Use a B or 2B pencil to add additional shading. You may also want to use the zero eraser to whiten any areas. The tortillon works nicely to soften the shading. Make sure you leave a little contrast and do not shade over all the white erased areas. If this happens, simply remove the unwanted shading with the erasers. Work back and forth with the pencils and erasers to achieve the look you want.

7 Add details to the background by placing a stencil back on and doing more erasing. Make sure you stay away from the central drawing. Soften the additional erased motifs to fade them into the background by rubbing them with the graphite applicator pouch or the tortillon.

Celtic Zero Drawings

Celtic knot stencils are particularly beautiful when done with the zero drawing technique. The bridges of the stencil were ignored when the motif was traced, leaving shadows automatically where the lines of the knot travel under one another. Refine these shadows with a little more shading and using the zero erasers on the highlights to give these pieces extra drama and contrast.

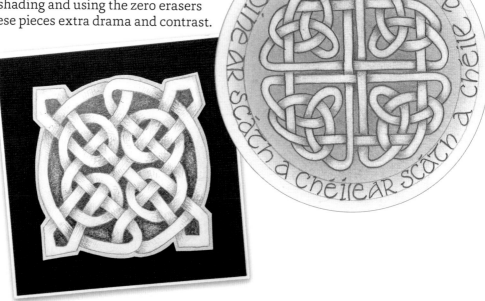

Shaped Background

The zero drawing technique can also be used with shaped graphite backgrounds rather than soft abstract ones as shown in the dragonfly step-by-step instructions. To do this, use a large, open stencil. Tape it to your surface and perform the graphite sanding and pouncing on the inside of the stencil. You can get into the very small details of the stencil this way. Remove the stencil and use your dust brush to remove any excess graphite around the edges. Then repeat the zero drawing steps by taping a stencil over the shaped graphite area and erasing.

The samples on page 23 illustrate the very different ways you can use a shaped background. With the heart shapes, one used a patterned stencil and the other a tree landscape stencil. The fan shapes show a patterned stencil and a butterfly motif stencil to further illustrate how you can vary the drawings.

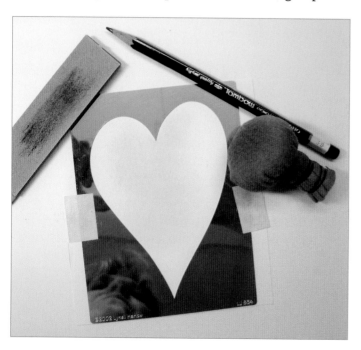

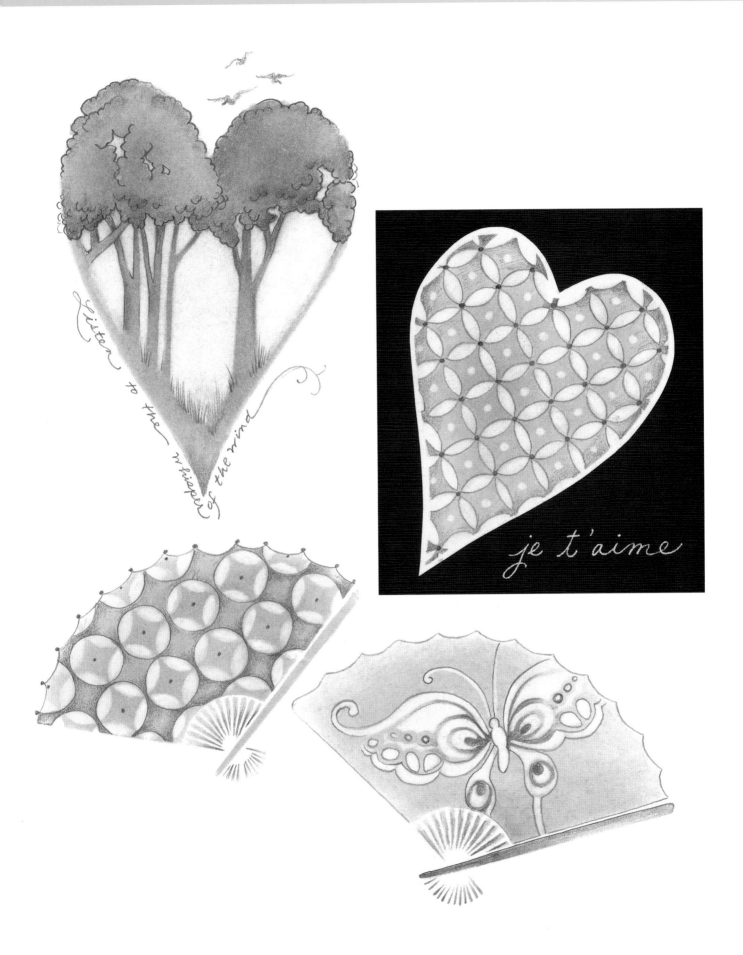

listen to the whispers of the wind

je t'aime

Technique 7:
Scribble Stroke

The scribble stroke uses a mechanical pencil and is an easy stroke for beginners. The mechanical pencil gives you a consistent fine line so you don't need to stop and sharpen your pencil. You can get into a nice rhythm making your strokes, reaching an almost meditative mood. The scribble stroke works on a wide variety of images, including lettering and larger digital images.

Materials

- Mechanical pencil (HB)
- Stamp
- Gray inkpad
- Paper

1 Stamp your image using a light gray inkpad. The best stamps to use with this technique have shaded areas to help guide you. You can also use a photograph and manipulate the contrast to give you clearly defined shadows. First use the scribble stroke by making repeated tight circular motions over the entire shaded area, using light pressure and a constant value.

2 Go into the darker areas with firmer pressure to get a darker stroke, and graduate your pressure on the pencil into the lighter values.

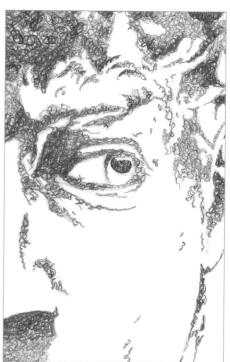

3 Refine your shading by adding darker areas or lightening highlights with your eraser. It helps to hold the drawing at arm's length and squint at it so you can see the contrast in the shading.

All About Colored Pencils

You can find colored pencils in two forms: oil based or wax-based. We will be working with wax-based pencils. Traditional colored pencils, like the ones used here, are also not water-soluble. (Water-soluble colored pencils, or watercolor pencils, are very different, and utilize different techniques.) Use good quality wax-based colored pencils—you will be disappointed with the results if you choose lower quality student grade colored pencils. The differences between a student grade and a professional grade colored pencil include factors such as the following:

Color selection. Professional grade pencils have a wide range of different hues and values, whereas student grade pencils will only offer a limited selection.

Wax bloom. Wax bloom is a light white haze that appears on wax-based colored pencil drawings over time as the wax medium rises to the surface. Even quality wax-based pencils will have some wax bloom over time. Remove wax bloom by wiping it with soft cotton wool, making sure you do not remove or move any of the pigment. Spray the surface of a finished piece with a workable fixative to prevent wax bloom.

Light fastness. How long a drawing lasts without fading is very important to colored pencil artists. Light fastness depends on the pigment quality and amount of pigment in the lead. Good quality pencils have good light fastness.

Point strength. Softer pencils with poor point strength are creamier and easier to blend, but tend to break easily when being sharpened or when dropped. Good point strength in pencils makes it more difficult to shade and color large areas, but lets the pencils stand up to vigorous sharpening and rougher treatment. Seek a middle ground point strength that offers the best of both worlds.

Irojiten Colored Pencils

The techniques in this book use Irojiten colored pencils, which I recommend, though you can use other high quality pencils. Irojiten colored pencils are premium, professional quality pencils. Irojiten is Japanese for *color dictionary*. They come in 10-pencil boxes that are labeled by volumes in the Tombow dictionary of color, and each set contains three volumes. The pencils have end caps that match the color of the pencil, and each pencil is labeled with the color name and number. The pencil number is one of the most logical numbering systems in the art world and is perfect for beginners who have the problem of choosing what colors to use. The pencil lead has a nice point strength, which results in less work to fill in color fields. It also keeps a sharp point longer for fine texturing. The durable lead and glued-in core also means no breakage in electric pencil sharpeners. The colors have a consistent finish, are excellent for blending, and don't muddy.

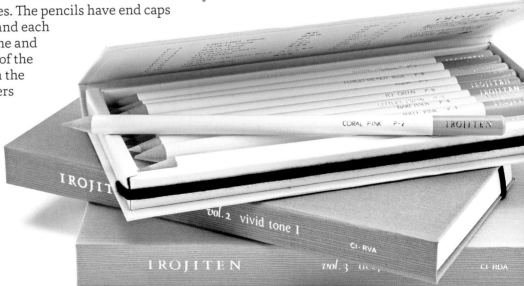

Supplies

Paper

When working with colored pencils, use smooth paper with a little "tooth." Stay away from really slick papers. The paper should feel a little rough to the touch. Also experiment with textured paper, such as a cold press watercolor paper. Good papers include Canson mixed media paper or Stonehenge papers. I also like to buy my paper in a pad, as it's easier to work with than large sheets and easy to keep dent-free.

All the samples below were colored in the same manner with the same colors (Irojiten colored pencils from the Vivid Tone I volume). The flower petals were colored heavily at the tips and layered with the yellow near the center. The leaf was shaded from the stem, with lighter strokes at the tip.

A. Stonehenge white paper. Excellent tooth, smooth, available in a variety of shades of white.

B. Canson mixed media paper. Lovely and smooth, available in pads or sheets.

C. 90 lb. watercolor paper, hot press. Nice, a bit more rough; shows paper through coloring; available in pads and sheets.

D. 140 lb. watercolor paper, cold press. Very rough texture, shows lots of white under coloring; good for when you want a heavy, textured paper. Available in pads and sheets.

E. 70 lb. kraft paper. Nice for vintage themes. Sometimes kraft paper can have rough spots, creating uneven values when coloring. This is a popular paper and easy to find in pads.

F. Canson 98 lb. pastel paper. Nice to work on, limited colors, available in pads and sheets.

G. Book pages. These are easy to find and fun to color. There is not as much tooth on some book pages, and vintage books can be quite fragile. I scan and then print book pages (and music sheets, vintage journals, etc.) onto drawing paper to work on (see page 44).

H. Decorative paper (scrapbook cardstock). This paper also comes in a huge variety of solid and patterned colors. The tooth varies from rough to very slick. Choose a decorative paper with a nice toothed surface. With the patterned pieces, choose light colors and simple tone-on-tone patterns for the best results.

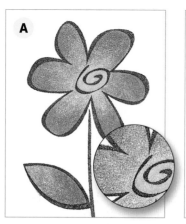

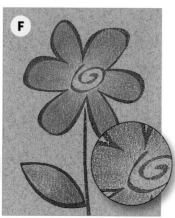
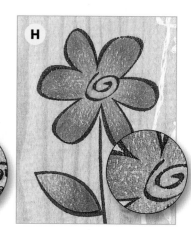

Blending Materials

My favorite blender is a dual brush colorless blender marker. It's easy to use and moves the pencil color nicely to fill in tiny white spaces and refine and soften your shading and layers. After the blending has dried, you can go over it again with the pencils. I also use very light dual brush marker colors as blenders; they give a brighter appearance to the colored area.

An odorless solvent such as Gamsol also works for blending. Dip into the solvent with a tortillon and use it to blend the color. The downside to the solvent is that you have to let it evaporate fully to evaluate your blending, which takes much longer than with a colorless blender pen.

Anther option for blending is artist quality colored chalk (or artist soft pastels) applied with a cotton swab. This tends to be messier and is harder to work in detailed areas. I use chalk when I want to add a nice softness to a drawing.

Erasers

A variety of erasers are available for colored pencil work. Kneaded erasers are good for removing pigment and shaping to get into small spaces. White vinyl erasers are useful for erasing larger areas. Small erasers in a pen form, such as Tombow's zero erasers, are excellent for getting into small areas. My favorite eraser when working with colored pencils is Tombow's sand eraser (shown below); it can take off almost anything and does not harm the paper. The sand eraser is also used with the subtractive stamping technique on page 44.

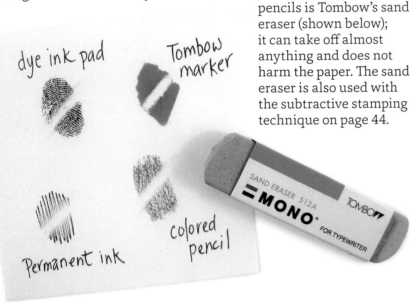

Pencil Sharpeners

As with graphite pencils, it's important to keep your colored pencils sharpened. Handheld sharpeners, electric sharpeners, or sanding blocks (such as sandpaper on a paddle) all work well with colored pencils. Sanding blocks are great for making chisel points, which result in a point for fine details and a flat area for coloring larger areas.

Rubber Stamps

Use your favorite images. I have tried to use a variety of different styles of stamp designs with the techniques so you can see what style of stamp works best. I also use digital images for colored pencils—you can resize, layer images, and basically do much more than with a regular stamp. You don't need to pre-treat the image, and it doesn't matter what type of printer you use. You do have to make sure you test the image first if using a colorless blender pen, Gamsol, or a water-based marker with your colored pencil work.

Inkpads

My main go-to ink colors for stamping images are black, sepia, and light gray. I prefer the VersaFine inkpads from Tsukineko. The images dry instantly and do not bleed with any blending solutions. Perfect stamped images to begin will ensure that your projects turn out great.

Elements of Art: Color

Basic Color Theory

Deciding what colors to use is one thing every project has in common. It is also an area in which many of us have the least amount of confidence. Color surrounds us and plays a major part in our lives; it creates impressions and elicits responses. The average person can see 1 million different colors and the trained eye up to 10 million. Just by working with color, you can start to train your eye to see more colors. Deciding what colors you want out of the millions possible becomes an awesome task. Color theory itself encompasses a multitude of definitions, concepts, and design applications, and fills several encyclopedias! However, everyone can learn the basics about color. The easiest way to begin is to learn about the color wheel and some general color terms. It's good to know how to "talk color" to give you some idea where to start when blending and adding color to your projects.

Colors can be divided into four groups:

- **Primary Colors:** red, yellow, and blue. These cannot be mixed from other colors. All other colors are derived from these three.
- **Secondary Colors:** orange, green, and purple. The three primary colors are mixed to form this second tier of color. Red and yellow make orange, yellow and blue make green, and blue and red make purple.
- **Tertiary Colors:** mixing one primary and one secondary color makes these colors. Examples include yellow-green, blue-green, and blue-purple.
- **Quadric Colors:** mixing two tertiary colors makes these colors. Examples include russet, cinnamon, citron, olive, forest, and eggplant.

To add further nuance, all colors can then be mixed further:

- **Tinting,** by adding white
- **Toning,** by adding gray
- **Shading,** by adding black

Color Terms

It's good to be familiar with the following basic color terms.

Hue refers to, and is another name for, color. For example, a red-patterned bowl has a red hue.

Chroma refers to the intensity of a color, how bright or dull it is. Scarlet red and brick red are similar in value, but their chroma, their intensity, differs. Brick red is duller, with a lower chroma than scarlet. Scarlet is more brilliant, with a higher chroma than brick red. Colors with low chroma have more of other colors added to them; those with high chroma are more pure.

Value describes the darkness or lightness of a color. A color that is light in value has been diluted with white. For example, pink is a tint of red and has a light value. A dark value color is closer to black on the scale, because it has black added to it. For example, burgundy is a shade of red with a dark value.

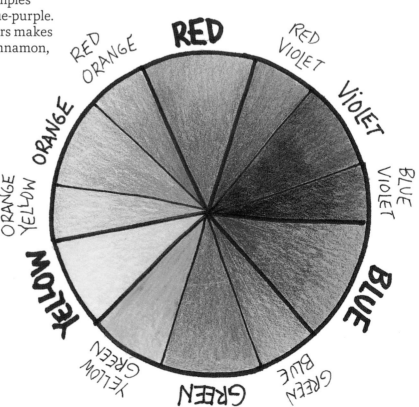

Irojiten Colors

The Irojiten coloring system is simple and unique: all the colors with the same tone are labeled with the same letter. For example all the vivid tone colors start with a V, pale tones with a P, and so on. This means that even if you place all your pencils into a single cup, you can easily pick out the tones that go together before you start your coloring. Each dragonfly on the right has been colored using colors from the different sets. Each turns out very differently, but the colors all go together within each piece. This makes choosing colors simple, with no mistakes—just use any colors from one set, and they will create pleasant color harmony every time.

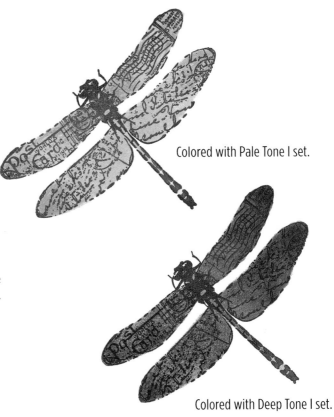

Colored with Pale Tone I set.

Colored with Deep Tone I set.

Color Harmony

When choosing what colors go together, you can also use some basic color combinations that are harmonious. Here are just a few of the most basic combinations you can use.

A. Monochromatic. Meaning one color, monochromatic combinations use tints or shades of the same hue. This is the easiest color scheme to start with. Here, different blues are used.

B. Adjacent/Analogous. This combination is made from any three colors that are side-by-side on the color wheel. This sample shows violet, blue, and green.

C. Complementary. These are any two colors that are directly opposite one another on the color wheel. Each warm color has a cool color as its complement. Complements create visual excitement and draw your attention. This sample uses reds and greens.

D. Neutral. Black, white, browns, and grays are all neutral colors that work well together.

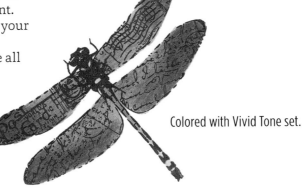

Colored with Vivid Tone set.

A

B

C

D

Blending and Layering Options

Basic Shading

The violet circle shows shading with one color from dark to light with no blending, just the pressure placed on the pencil to create the values. This is the best technique to learn shading with the pencil only, rather than always depending on a blender. Always start with a light pressure and gradually add more pressure for darker colors. The shading follows the contours of the circle in small back-and-forth strokes. The orange circle shows shading with multiple colors: maroon, red, orange, and yellow. Using multiple colors makes the piece richer and more interesting, and the different colors help to determine light to dark values.

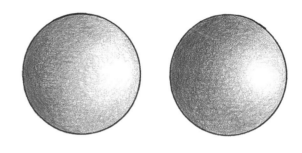

Color Layering

You can achieve beautiful colored shading by layering fields of different colors. The purple circle has been shaded with a layer of dark blue and light purple to create the color. The effects of color layering are shown dramatically on the colored leaf. The left half of the leaf was colored with yellow, blue, red, and purple to create an interesting shaded green. The right half of the leaf was colored with only green. Don't be afraid to use multiple layers of lightly applied colors to create a many-hued drawing.

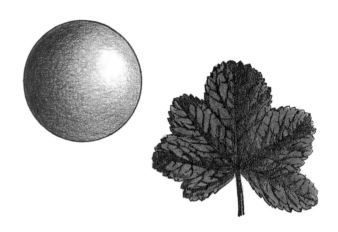

Solvent

You can move color around with a solvent to blend it. Gamsol is an odorless solvent that actually dissolves the wax to blend the colors. First layer and blend the colors with the colored pencil. Dip a tortillon into the solvent. I like to pour the solvent out into a small, low container so I don't knock over the bottle as I work. Use hard pressure and the side of the blending stump to softly move the colors together. The color will lighten up a bit as the solvent evaporates, so don't evaluate your piece too soon—wait a bit to see the final results. The green circle shows how the solvent fills the tiny white spaces of the paper, which results in a somewhat blotchy effect on a solid-colored piece. I like to use solvent for giving the drawing a soft blended glow, as shown with the dandelion.

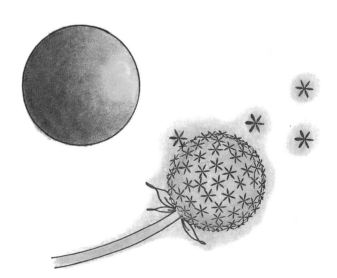

Colorless Blender

This sample shows blending done with a colorless dual brush marker, or colorless blender. It creates an even blend that dries quickly. When it's dry, you can go back into the drawing to add more color.

Burnishing

Burnishing is a traditional blending technique favored by colored pencil artists. It uses a very light colored pencil all over the shading to soften and blend the colors.

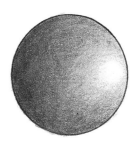

Sand Eraser

A sand eraser will also work to go over the coloring to lighten highlights and blend the colors. Start with very light pressure, and go back and forth between adding color and using the eraser to achieve a nice blend.

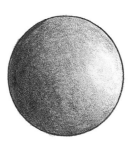

Colored Chalk

Chalk adheres nicely to the colored wax surface of the pencils. Use a cotton swab (one for each different color group) to overlay a soft blending color. You can use the same color, or play with layering different chalk colors on top. Chalks tend to be messy and harder to work with in detailed areas. Like the solvent, use chalk to add a nice softness to a drawing.

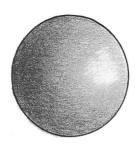

Dual Brush Marker

You can also use a dual brush marker in a very light hue to add a blending layer to your color. Here, a very pale blue was added onto dark blue pencil. This tends to really brighten and add vibrancy to the finished drawing. You can use the same color, or play with layering different colors on top.

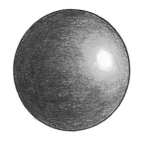

Basic Method for Blending and Layering

Follow the instructions here to practice the basic method for blending and layering color before proceeding with the other techniques for colored pencils. It will give you a good start. Take a look at the finished samples here too to get inspiration for your next project.

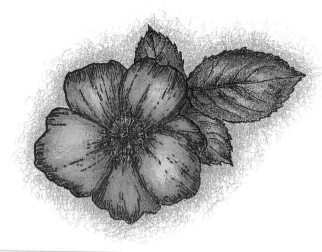

P-11
V-1
D-1
V-3
D-15
D-16
D-17
D-7
DI-7

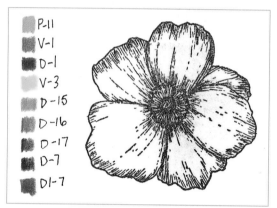

1 Stamp the image, then choose your colors. For this image, I selected three shades of pink for the flower, two shades of yellow for the center, three shades of green for the leaves, and a blue for a halo around the final image. You can draw a small sampling of the colors and their numbers to refer to as you work.

2 With the lightest colors and a very light touch, start to block in the color fields. Use the markings on the stamped image as your guide for values. Keep the pressure and color light, or you will crush the fibers that create tooth in your paper and be unable to layer more colors on top. Make sure you always have a sharp point: a dull pencil will result in tiny white spots.

3 With the next layers of color, slightly overlap the first color and maintain a very light touch. Keep adding to your color fields, following the contour of the image. Keep layering and going over all the colors, blending them with graduating values. Try to make sure you do not see any obvious pencil strokes.

4 Continue adding to your color fields. You now want to go over all the colors, blending them with light layers on top. By the end, you are applying more pressure as you build up the intensity of the colors. Pay close attention to where the color meets the stamped outline of the motif. Tiny white spaces are easily missed and become distracting in the final coloring.

5 Add a leaf using the masking technique and color it in. Add a light blue halo using the scumbling technique (page 36). Using the colorless blender, work from the lightest into the darkest colors to softly blend the colors together. If you cover up the light highlights when blending, wait for the piece to dry, and then bring back the highlights using the sand eraser.

Samples

Each sample shown here represents a slightly different mix of colors and techniques. Read below to get some ideas for your projects.

A. Tin Man Card: To achieve the metal surface of the Tin Man, use white highlights and dark shading with little graduated shading in between.

B. Butterfly Poppy Card: The vintage brown halo around the image was blended out using a colorless blender to give it softness.

C. Rose Postcard: The flower and the postage stamps were colored using the same color palette used for the flower.

D. Car Card: The only area blended with a colorless blender was the car. The rest of the piece was colored without any additional blending.

E. Vintage Pen Panel: A colorless blender was used on the color on the script in the center to blend out from a highlighted center.

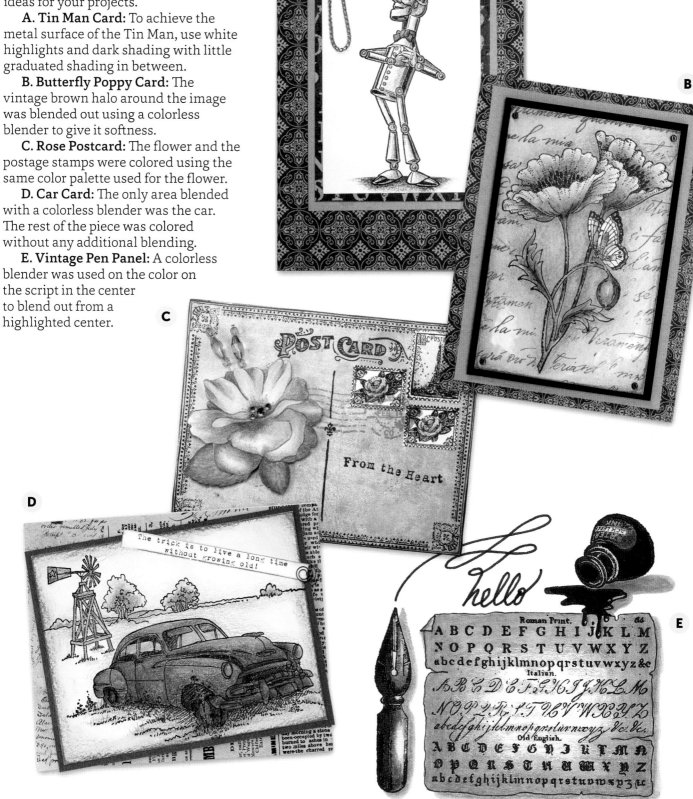

Technique 1: Hatching and Crosshatching

These are old techniques, favored by the masters such as Leonardo da Vinci and Albrecht Dürer. Hatching involves drawing values with parallel lines that follow the direction of a selected plane. Crosshatching involves lines that are layered at cross-angles to create darker tones and texture. For both of these methods, you need to keep your pencils sharp to create nice, clear lines. I also add basic shading with these strokes to refine small details.

Materials

- Colored pencils
- Stamp
- Gray inkpad
- Drawing paper

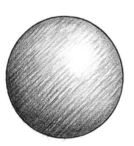

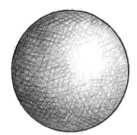

Hatching

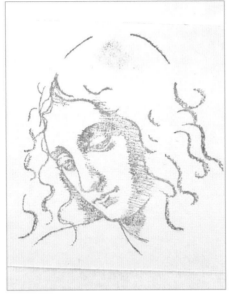

1 Stamp your image onto drawing paper using a light gray inkpad.

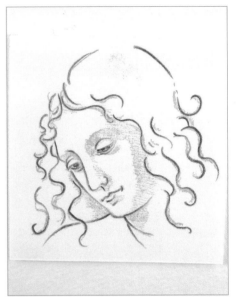

2 Draw the contour lines (lines that follow the edges of the drawing subject), applying varying pressure so the lines have thick and thin and dark and light areas.

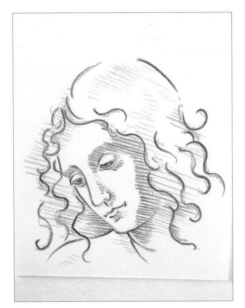

3 Make sure you have a sharp point on your pencil. Using a light colored pencil and with very thin and light marks, draw parallel lines across the entire image to denote the direction of the hatching strokes for the shading. I usually do not erase these lines on the final drawing. Place darker lines closer together in the shadows, and use lighter and thinner lines for the graduating lighter shades.

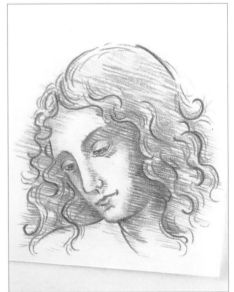

4 Continue to refine the shading by adding darker and lighter hatching for the shadows and highlights. Keep all the strokes parallel and straight using your lightly drawn guide marks from Step 3. You can reinforce the darkest areas with basic shading strokes on top of the hatching. Notice how the hatching goes past the image outline for an interesting da Vinci-like effect.

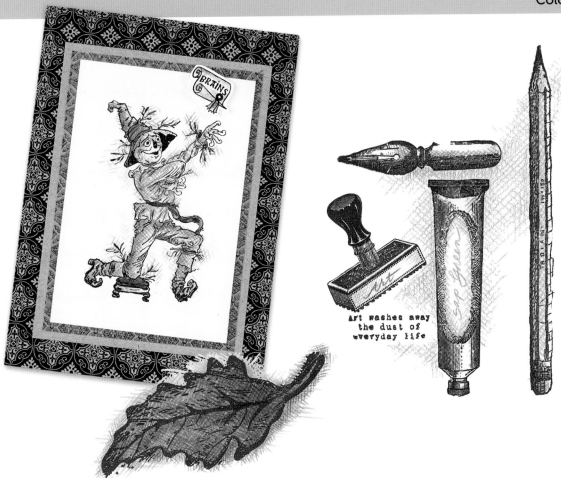

Crosshatching

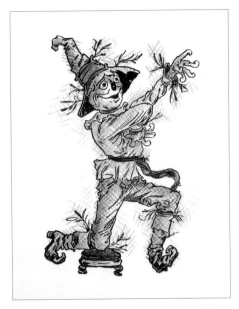

1 Start by lightly hatching in your color fields. Then cross the hatching with lines going in the opposite direction, adding depth and shaded areas to the design.

2 Basic shading is important to bring out the details, or you'll tend to get just a bunch of lines across the image that make the piece look busy. Refine and darken the shadows with basic shading and crosshatched lines.

3 Refine the lines and add crosshatching around the image. In this sample, the haloing crosshatching makes it look like the scarecrow is losing hay and adds interest and movement to the drawing.

technique 2:
Scumbling

Basically, scumbling is circular strokes. It is used by colored pencil artists to render smooth textures, such as skin. The strokes are very tiny, and you can't easily see them in the finished piece. I use it as a decorative stroke, as my go-to shading around a motif, and to add texture. You need to make sure your pencils are very sharp. This technique also works well with lots of different colors layered for a whimsical feeling.

Materials

- Colored pencils
- Stamp
- Black inkpad
- Drawing paper

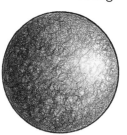

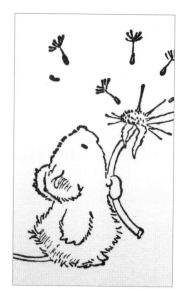

1 Stamp your image onto drawing paper using a black inkpad.

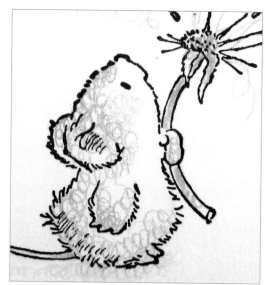

2 Scumbling is a fairly easy stroke to render; just follow the main rule of colored pencils by starting lightly and adding layers to get darker values. Try to hold the pencil with an extended tripod grip for very light strokes. Start with the lightest color and very lightly add scumbling to denote the different color fields.

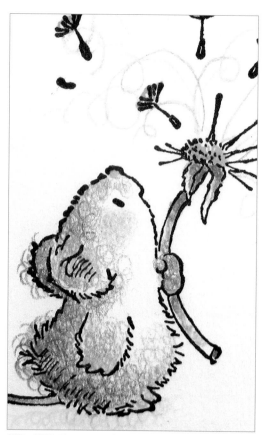

3 With the next color layer, add a bit more pressure, and make the circular strokes smaller and closer to the inside line of the motif. Adding basic shading strokes helps with filling in the tiny spaces.

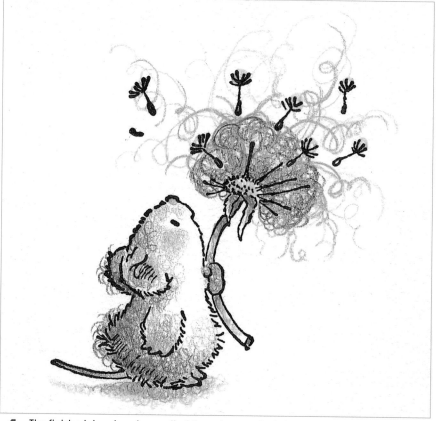

4 The finished drawing shows all of the colors applied. Scumbling adds beautiful texture to your drawing, and makes the mouse in this example soft and furry. The scumbling here really takes off in creating movement with the wishes blowing away from the dandelion.

Ideas and Samples

Some of the samples on this page, such as the oak leaf and owl, show adding scumbling to outline or halo an image. I really like scumbling when I have an image with swirls, like the owl—it helps maximize the movement of the swirls and curls, bringing interest and whimsy to the coloring.

Scumbling is also used to render a texture when coloring. When artists use this stroke on large drawings, the effect is amazing. You cannot see the individual circular strokes, because they are made very lightly and with many layers. Skin colored with scumbling looks like living flesh. Scumbling was also used for texture on the walnut in the mouse card; it gave the walnut a different texture than the mouse, which was done with the strike stroke, and the flower, which was done with basic shading. The water was also colored with light scumbling.

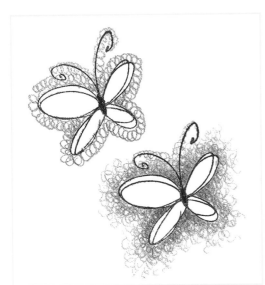

Scumbling Tip

Be careful not to repeat the circular strokes right next to one another, or else it will look like corkscrews all over the drawing. This often happens when you halo an image with scumbling. Keep the strokes random and going in many different directions. I noticed that while I do this stroke, I continually turn the pencil in my hand. It keeps the strokes working from a sharp point and helps to make them more random.

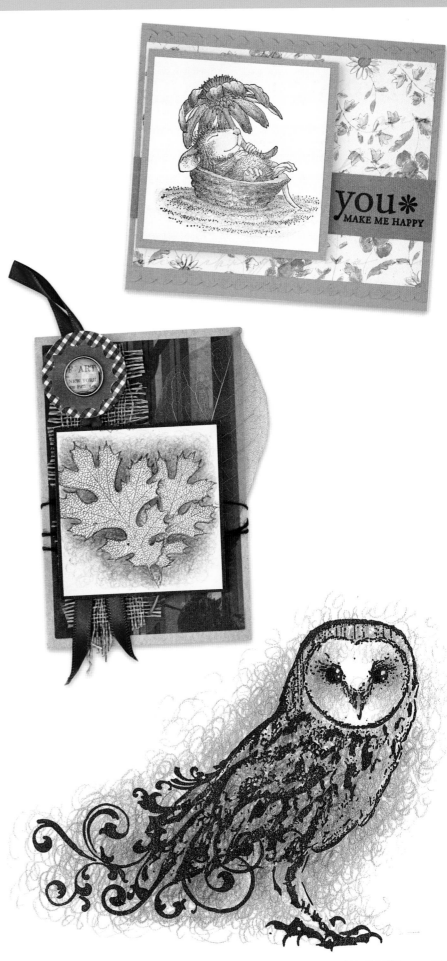

Technique 3:
Strike Stroke

Strike strokes are fashioned by striking the paper with a heavy landing and a smooth takeoff, using a flicking motion. This results in a varied stroke excellent for rendering grass, feathers, or fur. Look closely at the sphere sample: the bottom of the stroke is darker than the top. You need a strong, sharp point for this stroke, so sharpening your pencil using the sanding block and getting a chisel point works best. I usually add regular back-and-forth shading to the strike stroke.

Materials

- Colored pencils
- Stamp
- Gray inkpad
- Permanent pen with fine tip
- Drawing paper

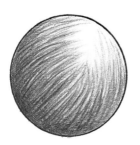

Ideas and Samples

The samples on page 39 can teach you even more about creative options with the strike stroke. For the cowardly lion image, I used a complementary color scheme, adding a dark blue with the brown and yellow tones. This added excitement to the finished look. The extra strike strokes around the head, following the contour, make it look like the lion is quivering, adding movement and personality. The owl was colored entirely with the strike stroke, again with the strokes breaking free of the original stamping to give him a real fluffy look. With the owl, note the unconventional layered colors used to make him really interesting. I left the branch uncolored to make sure the owl was the main focus.

1 Stamp your image onto drawing paper using a light gray inkpad.

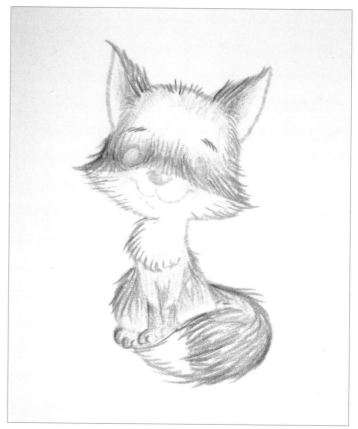

2 Make sure your strike strokes follow the contour of the drawing. Lightly use the strike stroke to block in the color and show the direction and size of the strokes. I used long strokes for the fox's tail and shorter strokes for the body and face.

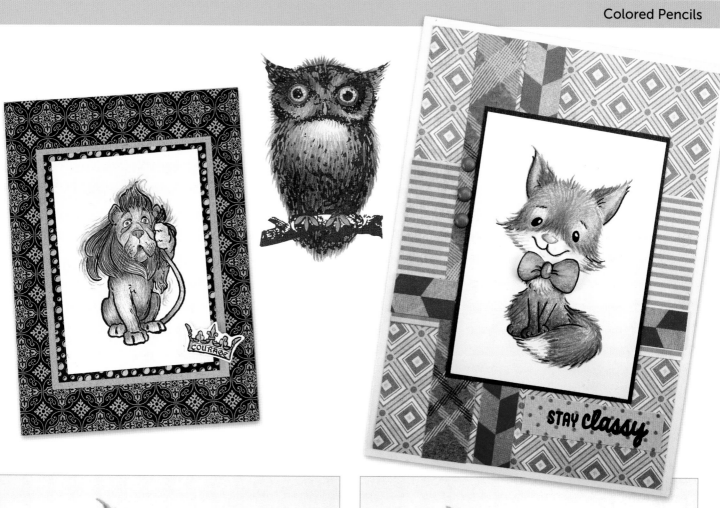

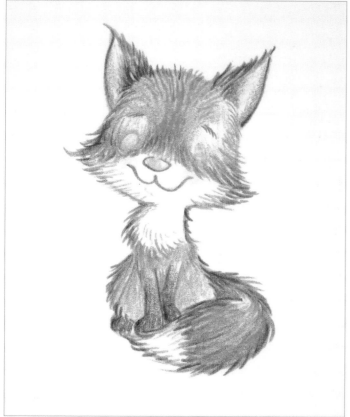

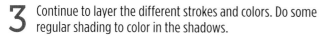

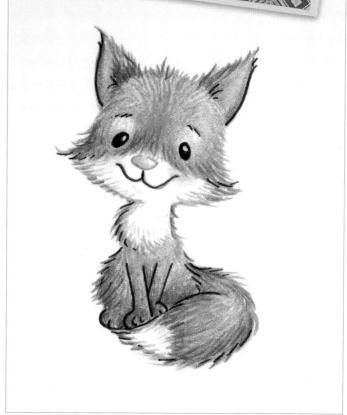

3 Continue to layer the different strokes and colors. Do some regular shading to color in the shadows.

4 Go back into the image with a fine-tipped permanent pen to bring out certain details. When coloring in the eyes, leave a tiny highlight, which makes them sparkle.

Technique 4:
Impressed Line Drawing

This technique involves making impressed lines on the paper with an embossing stylus before applying the color. The impressive result is a whimsical drawing that gives you permission to color outside the lines! The traced design is impressed into the paper using a heavy hand. You can shade with light or dark colors and the impressed lines will stay bold and bright white.

Materials

- Colored pencils
- Embossing stylus
- Small piece of paraffin wax or old candle stub (not colored wax)
- Low-tack masking tape
- Tracing paper
- Permanent pen with fine tip
- Watercolor paper

Impressing the Pattern

First, tape tracing paper over the design with low-tack tape and trace just the outline of the design with a fine-tipped permanent pen. You can overlap the motifs, group motifs together, or choose to leave out certain elements. You are the artist, so create the drawing you want.

Next, place the traced pattern over the watercolor paper. With a heavy hand, trace the motif with the embossing stylus. I work on a semi-padded surface, such as a piece of craft foam or cardboard, to maximize these impressed lines. To minimize drag, rub the stylus in paraffin wax to lubricate it. Work with a strong light directly overhead to see the subtle white-on-white impressed lines you are creating. Remove the tracing paper pattern to reveal the impressed line outline of the motif. You can go over these impressed lines again with the stylus to make them even more pronounced. After the main lines are impressed, add filler design lines. Do this freehand and press hard to create the deepest impressed line possible. These lines will be crisp and bright white. Vary the outline and the filler design line weights by using both ends of the stylus.

Coloring the Design

1 Start with a light shading of the color fields. Use a light touch and smooth movements. I go over and past the impressed outlines of the motif to make the line show up. It also adds a fanciful effect to the drawing.

2 As you continue to shade, press harder with the pencil for more intense color. The pink in this example has been shaded darkly and a lime green has been added and blended into it.

3 The final stage of shading uses darker colors and the heaviest shading to create the finished look. Do not be afraid to add lots of layers of different colors and darker hues for the most interesting drawings. While solvents and a colorless blender are great for blending colored pencils, they do not work well with the impressed technique. The color blends into the impressed lines, causing you to lose the design. You can use a blender if you feel the lines need to be toned down in a larger drawing.

Tips

This technique works best on watercolor papers, because you get a bolder white line using these soft, heavy papers. Choose the paper that you prefer; cold pressed papers are rougher, giving a little texture and allowing more of the white to show through, while hot pressed papers are smooth and make the white lines thinner. They all work wonderfully.

To create colored impressed lines, as shown in the sample below, shade the paper with colors before impressing the line. Shade on top using a darker or contrasting color to make the colored impressed lines show up clearly.

Design Ideas

Simple line drawings are all you need to get started. You can overlap the designs, vary the designs by making them larger or smaller, and select the filler design of your choice. You can get designs from stencils, copyright-free images, and your own imagination. To use a stencil, like the dragonfly image to the right, simply trace around the edge of the stencil with the stylus to create the impressed outline. Remove the stencil and complete the image with filler designs before coloring. Keep all filler designs simple, like swirls, crosshatched lines, circles, or scales. The 6-tree sample shows how you can vary the size and shape of a design and complete it with a variety of filler designs.

Using Rubber Stamps

You can also do the impressed line technique using a very light colored inkpad to transfer a stamped image onto the paper. Most of the design will be impressed to give the image white detail lines. The best designs to use are ones with many lines that do not need to be perfect for the image to work. Stamps with fur, feathers, hair, or grass work well.

1 Stamp the image onto watercolor paper with a light gray inkpad.

2 Add the impressed lines with an embossing stylus. Follow the inked lines, and add impressed lines in strokes that are right on top of the inked lines in the image. You will not see the inked lines at the end, and you do not need to copy every line, just enough so you can copy the image in a whimsical manner.

3 Lightly color in your color fields with colored pencils. Use a light touch and smooth movements. Keep the coloring strokes in contour with the shape of the impressed lines. I also color around each impressed outline line so the outline shows up nicely.

4 As you continue to shade, layer the colors and press harder with the pencil for more intense color. The final stage of shading uses darker colors and the heaviest shading to create the finished look. Do not be afraid to add lots of layers of different colors and darker hues for the most interesting drawings.

Technique 5:
Subtractive Stamping

When you want to use book pages and collected ephemera with the subtractive technique, it requires a different approach. Most ephemera are too fragile (and too valuable) for the technique, so you will need to transfer the image onto heavier paper. To do this, scan the ephemera and print them out onto smooth watercolor paper with your inkjet printer. You will need to cut the paper to fit into your printer tray. I usually cut a letter size, 8½" x 11" (or A4), sheet for printing. You can also use a color copier. If you can't convince the copy machine operator to use your trimmed watercolor paper, you can print on a heavier 80 lb. white cardstock.

Materials

- Colored pencils
- Sand eraser
- Clear stamp (rubber stamps can also be used)
- Gray inkpad
- Black inkpad
- Smooth watercolor paper (90 lb. watercolor paper works best, but you can also use drawing paper)
- Ephemera*

*Ephemera are items designed to be useful or important for only a short time, like pamphlets, notices, tickets, etc. My favorites include book pages, old script journal pages from older family members, and sheet music.

W troops once they had finished their gallant achievement of storming the Peking walls. The unarmed and bewildered Chinamen were many of them slain; then plundering began. The loot is said to have been enormous. The royal palace was broken into, and many of its most ancient treasures disappeared. The head officers of every nation strove to repress their men, but for several days Peking resembled some mediæval city suffering sack by the savage soldiery of that day.

Meanwhile, what had happened to the Chinese Empress and her court who had encouraged the Boxer movement? When the foreign troops began their actual attack upon the walls, the Empress and her suite marched forth from the royal palace surrounded by their most devoted Manchu regiments. They forced a passage through the crowds of terrified Chinese by firing rifle volleys into them; and thus as the Europeans entered the city from three sides, the Empress fled by the other. She and her followers did not stop till they were six hundred miles away in the far western city of Sian-fu. From there they opened negotiations with the allies, protested their entire innocence of the deeds of the wicked Boxers, and agreed to whatever terms of arrangement the Europeans demanded. When assured of their personal safety the Manchus returned to Peking more than a year later. The Empress resumed her autocratic rule over a nation which had never loved the Manchus

1 With a gray inkpad, stamp your image. This image will be very light; you only just need to see the basic image. This gray stamping will disappear in the final image; you are just using it as a general guide for the next step.

2 Using a sand eraser, remove the top layer of printed paper where your image is stamped to reveal the white paper underneath. This doesn't have to be perfect and white to every edge of the image—you just need the general area sanded white. Re-stamp your image in black ink. Using clear stamps makes it easy to see the gray stamping and line it up perfectly. Do not worry if you are a little off; the light gray stamping tends to disappear as you add the coloring.

3 Color the image using colored pencils and the general shading and blending techniques. Add a gray shadow around the stamped image using a very light gray pencil. This helps to illuminate any of the gray stamping and helps to frame the image. You can also use scumbling or crosshatching strokes to add the halo.

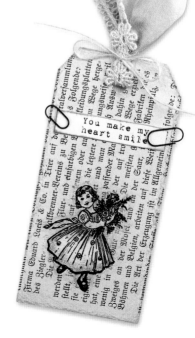

Tips to Remember

- Don't worry about erasing the images to the very edges; you don't want lots of white around the image.

- Faces are important to erase cleanly to prevent any of the background print from showing through.

- Clear stamps work best, as you can see to re-stamp over the gray stamping with the black ink.

- For any areas you want highlighted, leave the white uncolored.

- A halo around the image helps it stand out from the background pattern.

- Start to collect interesting ephemera for use as beautiful backgrounds with this technique.

technique 6:
Coloring on
Colored Paper

Working on colored paper is what colored pencils do better than markers! The shading, blending, and layering is the same as on white paper, but the finished drawings have a different dynamic to them. I usually add a halo around the colored image to make it pop off the page—light, dark, or matched to the paper underneath, a soft halo rendered with crosshatching, scumbling, or simple shading adds a nice touch.

A. Mermaid Tag: These aquatic cuties were stamped with black ink on light green cardstock. They were then colored and trimmed, leaving a slight edge.

B. Queen Bee Card, Poppy Card, and Zendala: These pieces are examples of stamping and drawing on kraft paper. Note the difference between the light yellow halo around the bee panel and the darker brown halo around the poppies. The light shades in the poppy card were important to make the florals stand out. Basic shading was used on the zendala, with a white gel pen providing dramatic accents.

C. Pastel Butterfly Panel: Pale tones were used to color the black ink butterfly, including a pale blue for the halo.

D. Blackboard Cards and Tag: Blackboard chalk lettering inspired these samples. Use very pale tones on black cardstock.

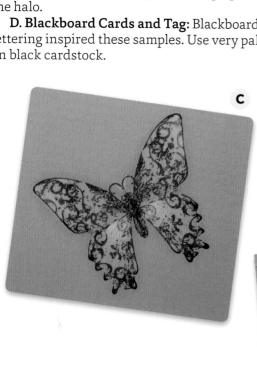

technique 7:
Coloring on Wood

Colored pencils also work very nicely on wood surfaces, especially wood-burned pieces. You can also stamp images onto wood to use as your image. It's important that you start with a very smooth and clean wooden surface for this technique. Here are some important tips to remember when using colored pencils on wood:

- Start with a very smooth, flat, and light colored wood piece that has been kiln dried and is ready for use. The pieces I used were from Walnut Hollow and were ready to work on after simply wiping off the dust with a tack cloth.

- Stamp the image on carefully using a black inkpad. You can also use stamping techniques such as the masking technique to design the area. If you make a mistake, you can remove the image by sanding the piece down. Make sure not to sand too much, as you could make the surface uneven and difficult to successfully stamp on.

- Test your chosen colors on the back or bottom of your wood piece before beginning to make sure you are going to get an effect you like.

- Use all the same techniques for coloring as you use on paper. Start with light pressure, and then layer and press harder for deeper tones. Use the sand eraser to bring back highlights and to tone down the coloring where needed.

- To protect your finished piece, cover it with several coats of water-based acrylic varnish. Always do a test on the back or bottom of the piece over the colored pencil. The first coat of varnish should be very light and thin to seal the color.

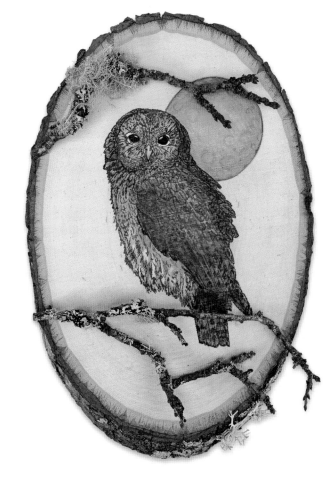

Technique 8:
Coloring on Photographs

Colored pencils work great for tinting photographs, especially black and white photos and vintage photos. You will need to scan and print out the photos onto drawing paper for best results. You may need to manipulate the photo a bit, such as lightening the tones or bumping up the contrast, to get the best workable photograph. Tinting colored photos can also work—try intensifying a colored area to make the color pop more.

The old black and white photos shown on page 49 are printed on drawing paper. Make sure you are printing black and white photos in color to capture the vintage sepia tones. I then used colored pencils to tint the photos. The left photo in each pair shows the original, and the photo on the right is the tinted version. Start with a very light hand and carefully blend the colors onto the photo. Don't worry about shading too much; the shadows in the photo will come through the color. Keep the blending very light! A colorless blender and a solvent like Gamsol tend to pull up the printed ink color, so just use pencils for this method. Use a white gel pen to add a tiny highlight to the eyes, as was done for the two photos shown at right in each pair.

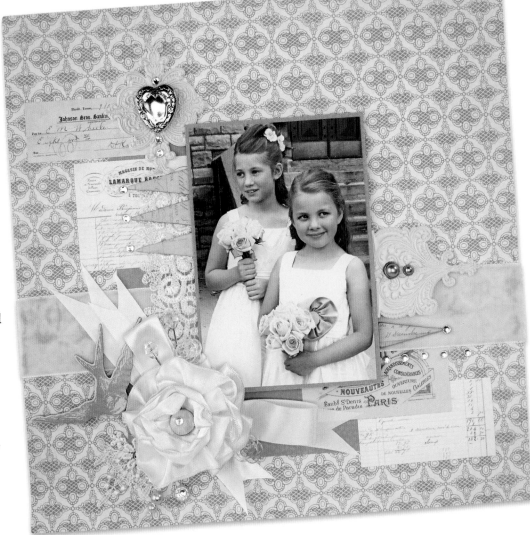

Tinting photos for scrapbook pages works nicely. Here, I manipulated the photo into black and white and added a slight blue tint before printing it out onto drawing paper. I only selected the girls' faces, skin, and the flowers to tint with the colored pencils. Use a very light touch when tinting for best results.